ABANDONERS

L. ANN
WHEELER

D1406468

THE OPERATING SYSTEM

the operating system print//document

ABANDONERS

ISBN:978-1-946031-26-6
Library of Congress Control Number: 2018948569
copyright © 2018 by L. Ann Wheeler
edited and designed by ELÆ [Lynne DeSilva-Johnson]
assistant project copyeditor: Careen Shannon

For additional questions regarding reproduction, quotation, or to request a pdf for review contact operator@theoperatingsystem.org

This text was set in Adieresis, Odieresis & Aring, Europa, Minion, Franchise, and OCR-A Standard.

Images are the author/artist's own, have been drawn from the public domain, and/or appear with permission.

Books from The Operating System are distributed to the trade by SPD/Small Press Distribution, with ePub and POD via Ingram, with additional production by Spencer Printing, in the USA.

2018-19 OS System Operators
CREATIVE DIRECTOR/FOUNDER/MANAGING EDITOR: ELÆ [Lynne DeSilva-Johnson]
DEPUTY EDITOR: Peter Milne Greiner
CONTRIBUTING EDITORS: Kenning JP Garcia, Adrian Silbernagel, Amanda Glassman
UNSILENCED TEXTS ASSISTANT EDITOR/TRANSLATOR: Ashkan Eslami Fard
SERIES COORDINATOR, DIGITAL CHAPBOOKS: Robert Balun
JOURNEYHUMAN / SYSTEMS APPRENTICE: Anna Winham
SOCIAL SYSTEMS / HEALING TECH: Curtis Emery
VOLUNTEERS and/or ADVISORS: Adra Raine, Alexis Quinlan, Clarinda Mac Low, Bill Considine, Careen Shannon, Joanna C. Valente, Michael Flatt, L. Ann Wheeler, Jacq Greyja, D. Allen, Charlie Stern, Joe Cosmo Cogen, Sarah Dougherty, Bahaar Ahsan, you

The operating system is a member of the Radical Open Access Collective, a community of scholar-led, not-for-profit presses, journals and other open access projects. Now consisting of 40 members, we promote a progressive vision for open publishing in the humanities and social sciences. Learn more at: http://radicaloa.disruptivemedia.org.uk/about/

Your donation makes our publications, platform and programs possible!
We <3 You. http://www.theoperatingsystem.org/subscribe-join/

the operating system
www.theoperatingsystem.org

For Leah

CONTENTS

A LITTLE HELL OF ITS OWN

Hurricane Sandy tore through Coney Island and set everyone back. *The New York Daily News* reported on the "Sandy Generation," and profiled children in public housing, separated from the shore by subway tracks and two blocks of amusement parks, who since the storm were unnaturally afraid of disasters. "The world is coming to an end. We didn't do nothing to God," Tyril said.

It's August, the week before school starts. I am exiting the auditorium during an orientation, answering the phone to find out whether or not our rental application has been approved. Last week a man was shot on Chauncey Street, in front of the building behind ours. The bedroom window was open at the top and the shots stopped whatever conversation my boyfriend and I were having in our lofted bed.

★★★★☆ *8/22/2007*

Went on a Saturday night, expecting long lines and attitude but was surprised to find quite the opposite.

Great outdoor area, we scored a table with benches and were able to chill out most of the night - yes, a lot of hipsters and guys with very skinny tight jeans - but I didn't care.

Drinks were served up promptly and bartenders came over when I made eye contact with them. Cool spot, would definitely go back!

Was this review ...? Useful ✓ | Funny ✓ | Cool ✓ |

What a strange day. I slept while the rain came in and made your things wet. The cable man is coming tomorrow. So life should be back to Awesome.

I can hear the baby of the man who was shot last week crying on the next block over.

The Honeymooners lived at 328 Chauncey Street in Brooklyn (not sure if it's Bed-Stuy or Bushwick).

— Joe

INFANT'S BODY FOUND

Roundsman Sheehan of the Coney Island police found the body of a new born infant lying on the sand under the Iron Pier at Coney Island Saturday afternoon. The remains had evidently been buried in the sand and had been dug out by the tide. The officer took it to the morgue on West Eighth street and the coroner was notified.

ITS SLEEP WAS DEATH.

The Discovery Made by a Young Mother at Coney Island.

Mrs. Lizzie Sherwood, of 224 East Seventieth street, New York, took her baby to Coney Island yesterday afternoon, in the hope that the sea air would benefit it. The child was suffering from cholera infantum. Soon after her arrival Mrs. Sherwood noticed that her infant slept, and she walked with it toward the water's edge. When near the drug store she found that her little one had passed from sleep to death. She shrieked hysterically and refused at first to part with the remains. After a time she was quieted, however, and the body was taken by undertaker Stillwell to await the action of the coroner. It was with the greatest difficulty that the mother could be made to understand at once that the law prohibited her taking the dead child back to New York with her.

TRIED TO DESERT HER CHILD

Mrs. Williams Told the Police She Found the Infant at Coney Island.

Mrs. Gussie Williams, who said she was 24 years old, walked into the Bergen street station house on Saturday evening, carrying a 17 weeks old baby in her arms. She told the sergeant at the desk that she had found the baby on the sand at Coney Island and wished to turn it over to the city nurse. When the sergeant began to question her the woman became confused and finally admitted that the baby belonged to her. She said that her husband deserted her about six months ago, after which time the baby was born. He had a daughter 8 years old. Her maiden name was Ebbets and her father, she said, was a farmer at Oyster Bay, L. I.

After being deserted by her husband the woman said that she went to live with a sister in Newark. On Saturday they went to Coney Island together and her sister advised her to abandon the infant. In fact, the child was placed on the sand, but she returned for it, as she had not the heart to forsake it. She then lost trace of her relative and decided to attempt to get rid of the infant by turning it over to the city as a foundling.

The woman was arraigned in the Myrtle avenue court yesterday morning and was sent to the almshouse by Magistrate Nostrand for thirty days. The child in the meantime will be cared for by the city nurse.

When I substitute for an elementary librarian in Kansas City, I read *Strega Nona* to a class. I model the three blown kisses she uses to make her magic pot of pasta stop boiling and then the children can't stop blowing kisses back at me. I have to ask them to stop blowing kisses.

On a cork board between the men's and women's bathrooms at a Pilot gas station in Iowa there is a missing poster for Elizabeth Collins and Lyric Cook. The center of the poster is a QR code made of pink and purple hearts. Last I heard, someone's parents were under investigation. An auto repair shop's security camera caught the two girls riding their bicycles down the street adjacent to the shop. The fuzzy-pink riders cut across the top of the frame; the street view is an unintentional capture and the most important thing it could ever do.

There are men who can crack up
there are men who can crack open the
ribcages of other men
 and tinker with the pink insides,
and then there's me I can hardly bother
to open my eyes with pointer and
thumb.

The Coney Island Houses were without power or
running water for weeks following the storm. When
the sun went down, it was dark. Hallways lit by groups
of bodega candles, stairwells appeared in the flick of a
lighter. In the morning, mothers filled buckets at open
hydrants to cook breakfast and flush toilets. NYCHA
still expected rent at the end of the month. A future
rent reduction was promised.

The people of the CI houses stage a protest in my dreams. In the now-shallow
shore, everyone is lined up by floor number in neatly parallel rows. The tide
comes in and out around their legs. I see this from above and also in tight shots
on their wet ankles.

An old man is found buried in the sand and no one knows if someone did it or no one did it. He must be moved. The protest continues.

In front of the bathroom mirror I rub Crystal Visions dream balm into my temples. I go to sleep and I am in New York, coming home from work on a Manhattan-bound B train, explaining to the co-worker who took the seat in front of me how much I miss holding the cold metal pole on a fast train going over the Manhattan Bridge. Then, there's the sense of being back on Maple Street, proximity of people being the strongest sensation.

Here, there is almost no one. Yesterday I sat on our root cellar and watched the trees' branches move on sky. Small planes flew over at what felt like regular intervals, towards the downtown Kansas City Airport. I closed my eyes and faced the winter sun for a long while. When I opened my eyes, everything appeared very blue, as things do in iPhoto when you drag the slide tool towards colder. This took whole minutes to fade.

Twists of fate are never simple: there is a date, barely visible in the concrete of the root cellar. 1917. I know everything would be easier if I didn't care about New York. Dear Kansas City expands in the view from my front porch, now that the trees have lost their leaves. At night it sparkles like an urban dream.

To enquiring friends: I have troubles today that I had not yesterday. I had troubles yesterday which I have not today. On this site will be built a bigger, better, Steeplechase Park. Admission to the burning ruins -- Ten cents.

- George C. Tilyou, posted on a sign the morning after the 1907 fire which destroyed Steeplechase Park

 Coney Island Cyclone
@TheCyclone

 Follow

"We will rebuild." Over 300 volunteers from Luna Park joined the Coney Island Alliance in clearing the boardwalk.
fb.me/SSBKpqxo

← Reply ⟲ Retweet ★ Favorite ••• More

2
RETWEETS

1
FAVORITE

10:33 AM - 12 Nov 12 · Embed this Tweet

The teacher refers to a blog post featuring microscopic images of sand from around the world. I've seen it. Each grain a surprising cosmos with colors and textures that cannot be seen at a glance.

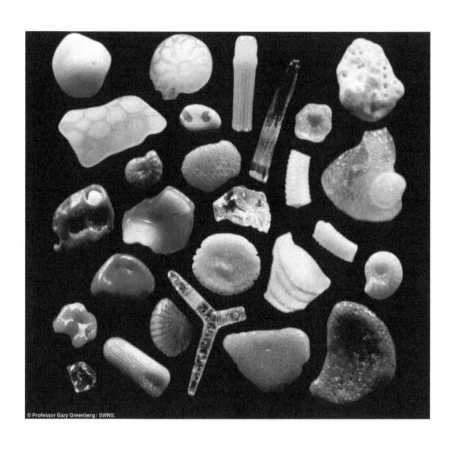

© Professor Gary Greenberg / SWNS.

A baby went missing in Gloucester, MA. A walk with her mom, older sister, and dog—a ball bounced, hers? Her sister's? Someone else's completely? The mother went to get the ball. She had to go under a footbridge. She had to go over a foot-bridge. She returned and the baby was not there. While she was walking away, while she passed under or over the bridge, while she ducked under to go back to her daughters, something had happened. The baby was not where she was before. The mother could not see the baby. They were on the beach. That night, and the next day, people searched for the baby. Specialists were brought in to question the sister. The specialists were special because they could ask a four year old questions "with sensitivity in mind." Who couldn't do this? On the second day since the baby disappeared, it began to rain. The searchers who dove and the searchers who combed sand and bramble could not search in the rain. The rain continued for three days. An Amber Alert was considered. It was dismissed because no one saw her disappear. There was no license plate number and vehicle description to flash over the highway.

An inquest will be made tomorrow.

An investigation is underway in Ankeny, IA. A man could not contact his son for three days. He went to his son's house. His four year old grandson answered the door and told him his father was sleeping. The father had been dead for a few days, in his armchair. Our friend lives in the neighborhood. He's seen a cop parked on the street all week.

Two bodies found by a hunter in the woods today. Although no one has confirmed it, people are reacting as if certain. I did not know until today that the cousins went missing on Friday, July 13th.

LIFE ON CONEY ISLAND.

Yesterday's Crimes and Casualties at the Seaside Resort.

The research never leaves you. More writing for just writing, running on the topic to anywhere. I was angry, washing a giant silver salad bowl. I didn't know I had just started to bleed.

The young woman from the fifth floor's baby died somewhere between getting in the elevator and reaching her apartment door. Shifting him in her arms to get her keys she realized he wasn't sleeping. There were screams and yelling and an ambulance. From my sixth floor bedroom window I saw women from the building falling over themselves crying. An empty gurney went in and came out with her on it, holding her baby close to her chest. The way she holds him, it's impossible for the EMTs to work. *It was with the greatest difficulty.*

A shrine grew in the lobby. On the floor next to the elevator were devotional candles wrapped in the images of saints, stiff new teddy bears, blue dyed carnations. A piece of cardboard taped low on the wall above the shrine held messages of sympathy and promised strength to the young woman from the whole building.

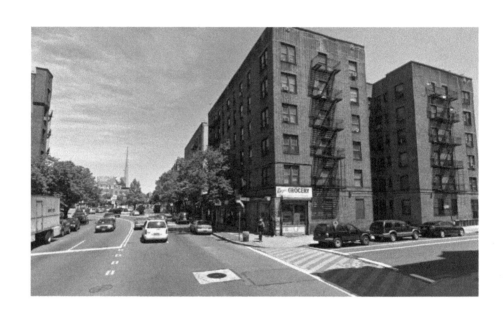

Coney's Games Still Go

and now the children are afraid
of snow, night in the hall

a society of abandoned children
we cannot muster the family

 they are owed / a parade

down fifth avenue ending
at the beach for summer sorries, so

As a first-year teacher in the NYC DOE, I receive: a clear trash bag with 12 markers, 24 pencils, a package of loose leaf notebook paper, two pads of easel paper and a classroom with eleven computers piled in a mouse-infested closet.

Sallie Mae called me nine times today. Their number ends in 3321. Normally I take any unplanned occurrence of 3-2-1 in my life as a positive sign, something saying *you're doing the right thing, this is the right path,* etc. The faculty member who hired me for my first adjunct teaching job was in room 321 of her building. When I worked as a camp counselor for an international writing camp in Iowa, my dorm room number was 321. We lived at 11 Maple St, 220 North Dodge St, and then 3308 Bell St. A natural progression, An order relievingly simple, and because of obvious contexts very primary.

SHREDDED CLOTHING FOUND ON BEACH
MAY BELONG TO MISSING TODDLER

GUT:
the basic visceral or emotional part of a person
part of the alimentary canal and especially the intestine or stomach

plural : fortitude and stamina in coping with what alarms, repels, or
discourages
to destroy the essential power or effectiveness of

In Gloucester, Massachusetts, the turbulent waves of Sandy brought tides in at record heights, and washed debris ashore. In the days following the storm, a man walking along Good Harbor Beach found a tangle of rope and pieces of fishermen's nets that had a shred of pink fabric caught in it. Somehow this shred of pink becomes reported, Caleigh's feuding parents are called to view it, and it is decided that the shred was part of the pants that she wore the day she disappeared. The conclusion is drawn that she must have wandered into the ocean and drowned.

MYSTERY OF A DEAD CHILD

Body of the Waif Picked Up at Coney Island Is Unidentified.

The police of the Coney Island Precinct have so far been unable to learn anything as to the identity of the infant's body found on the beach at the foot of Twenty-ninth street yesterday morning. A number of theories have been advanced as to how it came to be where it was found, but no facts have yet been brought to light to substantiate any of them. There have been no inquiries at the station house about the child, and no person has offered to identify it. The infant was about 6 months old, a boy, dressed in a long white cloak, with black stockings, no shoes and a white lace cap. It was partially covered by sand and had apparently been resting where it was found during all or the greater part of the storm of night before last. There were no marks of violence whatever on the body and nothing on the clothing by which any information as to its name could be learned.

THE
Pregnancy *Pact*

There is a day when all but two of the campers go to Des Moines on a field trip, and I am asked to stay behind. It is the fifth consecutive day of 100° + weather in Iowa, and so I decide to stay inside of my dorm room with the A/C pointed at the top bunk while I stream a Lifetime movie. It's a dramatized take on the 1998 incident at the high school in Gloucester, MA when the school was suddenly full of pregnant teenage girls. The made-for-TV-movie's angle is that of an investigative journalist returning to her hometown to gain true insight into the situation, but she largely becomes overshadowed by her bumbling use of a camcorder as a reporting tool. Her genuine care and compassion for the misguided teens is underscored when she offers to turn off the camcorder and just *talk* with them.

A hawk sat on a low branch over the playground at recess. His feathery brown back was to the children. I heard violins playing in unison. I'm overly warm, but I believe it is because I have on three shirts. The loan company called me seven times yesterday, nine before that, and so far four times today. There is a framed picture of Maria Montessori at this tiny teacher's desk. Is the sun out? It is cloudy. The Baptist church across Wornall Road is placing orderly rows of small white crosses in its yard. The seven colors of colored pencils are ordered by color in same-colored cups. It is nearly time for dismissal, I can hear the spinning wheels of the janitor's bucket.

a·ban·don[1] ◁)) [*uh*-**ban**-*duh*n] [?] Show IPA

verb (used with object)

1. to leave completely and finally; forsake utterly; desert: *to abandon one's farm; to abandon a child; to abandon a sinking ship.*

2. to give up; discontinue; withdraw from: *to abandon a research project; to abandon hopes for a stage career.*

3. to give up the <u>control</u> of: *to abandon a city to an enemy army.*

4. to yield (oneself) without restraint or moderation; give (oneself) over to natural impulses, usually without self-control: *to abandon oneself to grief.*

5. *Law.* to cast away, leave, or desert, as property or a child.

6. *Insurance.* to relinquish (insured property) to the underwriter in case of partial loss, thus enabling the insured to claim a total loss.

7. *Obsolete .* to banish.

Etymologically,
the word carries a sense of "put someone under someone else's control." Meaning "to give up absolutely" is from late 14c. Related: Abandoned; abandoning. The noun sense of "letting loose, surrender to natural impulses" (1822) is from Fr. abandon.

relinquish *to*,
surrender control *to* another power

If the baby is left in the sand, what power is asked to take control?

ABANDONED HER CHILD

On the night of September 3, Arthur Knox, a lineman on the Nassau Railroad, found a two months old child on the beach at Sea Gate. The infant was placed in charge of the city nurse by the Coney Island police and to-day Detective McCluskey, in whose hands the case was placed, arrested Rose Shaughnessy of 6 Clinton avenue and Mary Beuner of 176 Flushing avenue as being responsible for the child's abandonment. The former confessed to the detective that she was the mother of the child, saying simply that wanted to get rid of it. When the woman were arraigned in court, the case was adjourned until October 1.

MOTHER PETS BABY SHE HAD ABANDONED

Child Left in Coney Island Marsh Holds Out Its Arms as She Bends Over Crib.

SHE BLAMES TAXI DRIVER

He Said Child Would Be Picked Up in Half an Hour—She Is Locked Up.

I fall asleep in fleece sheets and wake up after a nightmare. I move to a recliner. I fall asleep two hours later. In my dream I visit a psychic I know and have visited with before. She knows me. I don't have an appointment but she is ready for me and asks me to have a seat on her couch. I need to focus more on the women in my project. A psychic in New York needs a personal assistant. She is comforting, understands my anxieties, and laughs them off. When our time is over I ask her *how much do I owe you?* and she reminds me my special price is $16. I hand her a twenty and she hands me a twenty and a five back.

I make a note to myself to smile more. It becomes more and more difficult to remember. You describe the music as "all travel; no arrival," and I become paranoid that my life follows the same pattern despite my desire for the contrary. Patternless laps around the country. How foolish my little lines transversing the globe are. And for what? I flew at high altitudes for hours and threw a coin in a fountain.

PART OF A BODY FOUND.; The Remains of a Woman Recovered at Coney Island.

[DISPLAYING ABSTRACT]

The lower part of the body of an unidentified woman was found yesterday afternoon floating in the water at the foot of Kensington Walk, Coney Island.

✉ E-MAIL

🗐 PERMISSIONS

———

Page Removed

We're sorry, we seem to have lost this page, but we don't want to lose you.

Coney Island is my playing board, the ocean the southwest border. The surface ends not far from there and the top is an avenue with auto repair shops, ATMs, and a thousand shuttered windows. And all the deli men are in dirty plastic candy thrones. I play my pieces all over it, entering and exiting the game on the elevated path of the Q train. The map is glued to a foldable square of cardboard whose edges are tucked over with linen like the headband of a book. It's an original contour drawing of a brand new coastline filled with Dutch rabbits, printed off of the internet yesterday. There are eight men in a row who are asleep on the train. Only one man opens his eyes at each stop, the others know when to get up.

This boat has wings, they flap when we settle in to our plank seats,
the man announces the start of our journey, we fly on.
My sweetheart, my man on the moon. What an odd place to land
after the Whip and Top, the Down and Out Slide,
the Ghost Train, Honeymoon Lane, the Hell n' Back walkthrough.

In my dream I am with children at an elementary school, and I try to teach two lessons. Neither are successful, both are simple and contained on a single piece of paper—thick like cardboard. Each time I present a lesson to a child, any child, their head would start to itch or they could look anywhere but the sky.

December 14, 2012

This school used to be a Montessori school. It's written in the concrete pillar outside. *Good luck*, a teacher says to me in the hall—a reflection of her own struggles more than how my day will go, I remind myself. Zonnie can't understand why I walk backwards as I walk the class down the hall. And why I sometimes switch to walking frontwards. I tell her I learned how to do it at teacher school.

The windows are opaque. They let in light and shadows, but you can't tell what's out there until it comes real close—a face with a hand cupped at the brow, a basketball's quick approach and disappearance.

The pledge starts at 9:35. Murmurs from all directions. *Liberty and justice for all,* the child's voice crackles with extreme volume on the PA, the excitement of being the loudest of all in the whole building. Office phone ringing in the background. On the regular teacher's desk a Bible quote typed, printed, and taped carefully.

POVERTY GAPPERS PLAYING CONEY ISLAND.

EXPENSE OF

I.

The basement was still full of other people's things. Decades of tenants' unwanted items—an armchair costumed in boxes of hangers, a picture frame resting on top; two faces smiled behind a layer of dust and glass. The octopus-shaped furnace sighed and shuddered through winter. A windowless room of Christmas decorations she only ever stepped one foot into. Behind a partition of wainscoting: a toilet with a dry and dusty bowl, suit jackets piled on the tank. At this point, houses on neighboring blocks were empty of everything. They were simply familiar-shaped husks that caught air for a moment or two until the air moved on.

II.

Before everything, they would spend evenings at the
neighbors' house, watch entire series of movies with
brave female leads, drink entire bottles of vodka
tucked in the freezer. She'd make her way up their
wide-planked stairs to the bathroom, and stop to take
in the view from the landing. How different the same
neighborhood looked from a slightly different altitude;
more southern, a house to the west. The neighbors'
bathroom was tidy, with dark navy blue walls. The
same copy of National Geographic was always on
the radiator—"Rome's Bad Boy: Nero Rises from the
Ashes." Bottles and containers arranged thoughtfully
in the corners of the bathtub. Next to the sink, a bar
of soap that smelled dense like raspberries reduced to
compote. The bar had small metallic stars embedded
in it. Each wash brought the stars closer to the surface.
She sunk her face into their towels and inhaled, playing
the game of guessing whose was whose. It couldn't be
strange when she knew them so well. It wasn't difficult
to go back downstairs and rejoin these movies already
in progress; it was clear who would win before they
even began.

III.

Submerge a pinch of salt in a clear glass bowl of water. Hold this with your right hand. A lit black candle in your left. Light incense. Choose one window in your house to open a crack. This is where the negative energy will exit. A single space to push it out of the house. She explains all of this to me. She only had to do it once. Things got so bad at her house that it growled in her children's ears. *Once you've opened the window just a tiny bit, stand in the farthest room from it and fill it with your prayers.* She says prayers, and concedes a Catholic upbringing which engrained the verse into her rituals. I replace *prayers* with *mantra*; a word that still doesn't quite fit, but by it I mean a phrase that makes me feel like my insides glow gold, my mind goes away when I say it. As children they took us to tour the prison. My friend and I, scared in the back seat of the bus as it pulled past the wire-topped gates, chanted the mantra I had just learned from listening to my mother's old records. *Hare Krishna, Hare Krishna/Krishna Krishna/Hare Hare Hare Rama/Hare Rama*—we said it together, we squeezed each other's hands. She and I never talked about this once our afternoon at the prison was over.

IV.

In another life he and I lived in New York, and did
things like spend a weekend with a healer. We sat on
cushions with other city dwellers a floor above a new
age shop in midtown Manhattan. We'd meet there after
class, pick up crystals and try to feel shifts, flip through
the pages of *Awakening Now, The Power of Breath*. In
each aisle a security camera watched us palm rose
quartz and run a tiny rake through a tiny sandbox.
Small round tines left waves. That weekend *Mother*
would lead us in meditation. She entered the room
once we were all seated, draped in marigold fabric.
On Friday and Saturday, after a day of meditation we
took the subway silently back to our apartment. On
Sunday, the final day, she greeted us individually, and
revealed our mantras. It becomes my *prayer*. I say it
until the room feels better, until the room contains
only exhalation. *The salted water absorbs any energy
that is not forced out the opened window.*

I do this in each room, each cabinet, each bookcase,
each closet. She tells me not to skip any closed-off
space because *the growl can hide anywhere.* The hallway
between our bedroom and the front porch is present;
I am met there. I speak, I fill, I listen for a response.
When I hear nothing, I move to the next room.

V.

Shut the window, blow out the candle, and walk outside off your property. Throw the water and salt from the bowl over your right shoulder and don't look back. I needed it *gone* gone, so I walked to the apartment building across the street and put the half burnt black taper and the clear glass bowl in the dumpster. As I walked back to the house I stepped over the puddle in the road.

Some days are realer than others. Some days the mocking bird slips a ringtone into its repertoire. It was just me. All of the frozen pizza nights couldn't have prepared me for an alone like this. How many miles until the gas is gone? The light no longer works. Sifting through abandoned cars a treat. Broken windows held deliciously together like panes of sugar, crumpled with a grab.

IN SERVICE OF HIM

OR, WHAT I THOUGHT SERVICE WAS.

There are so many strange, inside-out stories and confused afternoons it's easy to convince myself there's no need to even start. No need to set out into a landscape that only I know, but even I don't quite know how to describe.

Halloween at my first apartment in Brooklyn, the first party I've ever hosted, and my boyfriend breaks up with me. It's 2005, I'm twenty-one. As he tells me it's over, I ask, *But who will I learn things from?* I mean this. I'm wearing a costume I don't remember. Of course, now I know the answer to my own question is myself. But then, I had built my self into an identity that would only work if he was still around. I didn't feel I had intrinsic worth that could rival the worth created when he was my boyfriend. He's a poet. An artist. All of it is embarrassing, and all of it still surprises me when I least expect it.

I felt romantic when he gave me a small poem written on heavy paper, an intentional smudge of blood adorning the margin. I put it next to my bed, kept it in the plastic bag so as to not harm it. Coupling it with having met him on New Year's Eve when he almost ran me over with his car wouldn't spark a twinge in me until years had passed.

But he had been through a lot. He was getting better. I could help.

It's embarrassing because I put up with a lot of bullshit. I thought it was a rite of passage. I lived out so many tragic story lines in one year without realizing that those storylines never end well. Other people saw me, and I cringe to think of them seeing me—even though I know it's the wrong thing to cringe about. No matter how many times he would get kicked out of bars, or say the wrong thing to the wrong person at a party, I would help him up, exit with him, and watch him do coke with friends who barely said a word to me. I felt *lucky* to be acknowledged, to be of *service*.

Huge swaths of my insides are mine alone. I never tell anyone, I never show. Once I wanted to show the whole city who I was. Once I couldn't wait to show more. Now I show selectively.

The more time passes between me now and me then, the more rounded the edges of the stories become, the more I question my devotion to someone who didn't care. A party in Clinton Hill runs too late for me and instead of leaving and just going back to my own apartment, I sleep in his car on the street and wake up to him banging on the window, naked and bleeding. I have no idea what happened while I slept in his car, but I do know that I found him clothes in his trunk, drove us to the emergency room, and stayed the day with him as he sobered up and eventually got the gash on his hand stitched shut.

I learned what *persona non grata* meant when he tried to get into my dorm with me, but couldn't. He ended up puking in the dirt around a tree on the sidewalk, and I had to stave away the campus security guards: "No, no—he's okay; we were just leaving; I am watching him." Something happened before, something about heroin, something that meant he couldn't take any more classes for a while.

He proposed with a paper ring at a diner, and then acted as if it never happened.

Eventually, he came to the city less and less and I started to take the NJ Transit bus to his parents' house, and I kept taking the bus to their house for the weekend, even after he choked me one night in bed without explanation. (Not that there is an explanation that would satisfy; more than the overwhelming isolation I felt when this happened, I felt the most gravity in his silence, the way he never brought it up again.) It was a day, it was a holiday, it was a day I chose to be there because his parents were not. We slept in his parents' bed, large and luxurious. Usually, he never touched me. I was convinced he knew something I didn't and wanted to figure out what it was, at my own expense. I don't know why. I don't know why I didn't just say *no* when he wanted to fuck me over a carriage house's trashcans in the dark, or in the sculpture garden on campus. I did not want to do those things. But I did not say no. I wanted to be of *service*. Where does this leave me?

Instead, on the weekend I drove him to Borders in his station wagon and had to prop him up as he looked for a Belle and Sebastian album, because he was too drunk to stand on his own. Later, he'd tell me how I'd never write good poetry, never write anything that mattered.

Oh, get me away from here, I'm dying—

Now I shirk when my husband tries to kiss my neck, because then, in that bed in New Jersey, this other person put his hands around my neck without telling me what was going on, or asking me if it was okay, and kept them there for long enough that I felt my smallness and aloneness in a strange house in a strange town zoom away from me into the clouds.

I fell asleep in the same bed, after.

I began to step away from *service* on a corner outside of my internship in Park Slope in November, when I called my mother to say that I needed help. All I can tell her is that he *did not treat me well*. And that's about as far as I could articulate my experience for at least seven years. Instead of explaining to my doctor what has happened, I rely on the humor of an advertisement for an antidepressant where a little cartoon cloud follows the sad person wherever they go. I tell her *I have that cloud*, and that *I'd like that medication*, and I get it. The commercial implores *You just shouldn't have to feel this way anymore*.

There are friends from this time in my life who I have lost entirely. I could write them and try to explain what happened, but it's too far gone. My approach from the beginning was to record over the past with the present. Forget about the stars you saw when you were on your back in the wet grass, the way you zoned on them, to escape the physical realm. Am I the witch, the hunt, the hunter, or the watcher?

I forgot in *service* to him, and forgot myself entirely.

THE QUIET POEMS

I died three times last night
of a ceaseless not knowing—
the expense of valuing one person too much
of seeing myself inexactly in her path

An unexpected, unwelcomed question and the dizzying effect.
How she leaned over the table to look at me as if something could be
understood with a glance.
No one has ever looked at my body
in search of that information.

Part of it is having a way to be,
a way to unfold
palm on the outside of the plane
palm full of cards

Is the urgent advice of someone I admire
worth more than my own inclinations? This is where
I stumble. A life of decisions shot
through with uneasy doubt.
I put my hands over
hers as a way of saying hello.

I try to re-envision my life with a shadow,
a small shadow in the empty room.
Next to me as I do things.
It's been cut out. No. Has never
existed, appears only as a possibility,
a blank bundle.

This is a drawing my hand
cannot manage. My identity
is in an envelope, being slid
under glass to someone ready
to receive it. There is only
my hand, their hand, and my
identity in an envelope with
the flap tucked in.

Wreathed

Hazy over-rosed sky unfurls in my gut, becomes
familiar like mimeograph tones, off-ramps I should know
unfold shell within shell, a car dealership succumbs
to the king sized billow of a custom flag blowing—

Each time I tune in, delicate to understand
nothing, really—this hairpin turn could be
mine to trace over and over. The void bumps into me. It grazes my hand
in the shower, it selects a card. I turn to see who haunts me.

When I can get up before noon, sun warms the linoleum
where I stand to make coffee. The kitchen spider is translucent
but not dead. The tower is behind me so I let lonely
slips settle. I hope to bisect into glitter, I went

upstairs, downstairs every day. An award for leaving it all unfinished.

I.

Fourteen hundred miles to the ocean, my husband, my sister, myself and two dogs in our small yellow car. One dog sat below the dashboard, I fed him treats laced with tryptophan the whole way. We reach the yellow-glow cottage at three in the morning, our parents stayed up to greet us. They marvel at the distance we've travelled; we marvel at being bodies at rest. As they meet, my mother's dog and my new puppy lunge and snap. My mother kicks her leg up from the couch to say *stop!* and my black and white dog's mouth lands on her calf, planting a bruise that will grow deeper and bluer than the hydrangeas that flank the driveway as our week together unfolds.

II.

Our family rents a beach house for the week because we miss each other, and it seems like a good idea. It is small but bright, our three dogs do not get along well. The second to last night, our mother buys bottles of sweet coconutty drinks that have a high alcohol content, and my sister drinks many. My sister cries outside on the patio after dinner to me and our parents, in the summer-dark of the sleeping, ocean-air neighborhood. *I will never have children, I will never own a house, I will always have student loans.* She cries and cries and inside the house our father asks me if she is okay, and I tell him *Yes she's fine, she's had a lot to drink, student loans are overwhelming.* Our parents reassure us that they don't care if we are the *end of the line.* We can have children or not have children; it does not matter.

Small settlers pitch tents in my heart, sometimes
for just nights at a time. Their tiny
pins and hammers beat at me in a way
that only I can feel—inexplicable like communicating
an itch; I can't
tell you any more.

Thank you for reading my messages. The first thing I will tell you is that it's night, but not all the way dark.

A sparrow with fluttering under feathers is wings-in dead on the sidewalk. Two women walk by and give it space while making surprised sad faces. A tall lady wearing an outfit of neutral linen tones brushes it with her right foot and unknowingly turns the sparrow over onto its left side. When she looks down to see what she bumped she makes a face of disgust and flaps her hands as she walks into the tea shop. A young man in short, fitted mustard yellow shorts and a tucked in white shirt exits the tea shop and kicks the bird. He doesn't look down or back, but keeps walking. He's wearing brown top-siders. Every time the door opens, I can almost see the name of where I am.

Her beak is slightly open. A skateboarder jumps and nearly lands on the sparrow. He doesn't. I hold my breath, but the skateboarder's aware. A shadow of a bigger bird flies over the sparrow. A woman exits and points at it with her left hand, wrist tightly circled with a silver watch. A couple in black walk by in matched stride. A man in a Harley Davidson shirt points it out. Two ladies in green walk by twice and don't see it either time. A tea shop employee wearing a single plastic glove picks him up and puts him in the nearest tree dirt square. Sparrow at rest. The girl with the plastic glove is beautiful.

My tiny telescope has double vision. In the grass with a handful of sugar, it melts into the lines of my cupped palms. No one will eat it except me.

ABANDONERS

NEW YORK - During the last week of August 1922, sewers and subway trains backed up with a summer rain. It was the kind of rain that steams off of hot pavers and buildings as it falls on the city. Patriarchal religions scare me, and the only time I ever prayed with the intention of *praying* was when it was homework for CCD, but this bit means something to me: during that storm, a bolt of lightning struck the steeple of the Roman Catholic Church of the Epiphany in Brooklyn, the electric lights went out and a fire started behind the altar—and not one of the twelve people in the church stopped praying.

Causalities are comforting, even if they're tenuous. Four days after the fevered twelve made the paper for their unflinching devotedness, Leah Silver was held without bail for abandoning her daughter Ruth on Coney Island Saturday, July eighth.

She had
two
names

the press
gave
her
two more

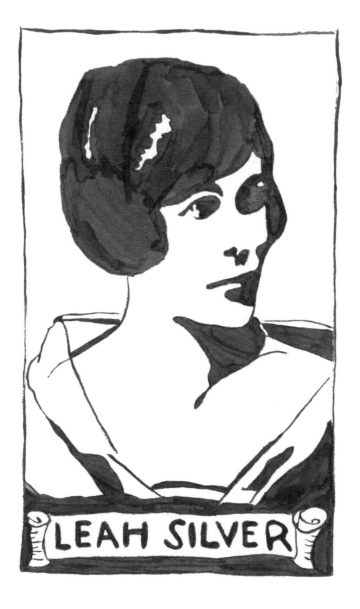

LEAH SILVER

	1.			2.	3.	4.	5.
1	Silver Rebecca	Head				38	Widow
2	" " Morris	Son	18				Single
3	" " Harry	Son	15				"
4	" " Leah	Daughter		⌐	9		twins
5	" " Betsy	Daughter			9		
6	" " Ada	Daughter			4		
7	Dudley, Charles	Lodger	54				Single
8							

Leah Silver was born and lived until age nine in Hull, England when she immigrated to Lynn, Massachusetts in 1913 on the Mauretania. She may have had a twin named Betsy, or it could have been that a British Census worker wanted to go home, and counted Ruth's friend as such. Betsy is listed on the 1911 census of England and Wales, a bracket and *twins* penciled in on an otherwise inked form next to Betsy and Leah's names.

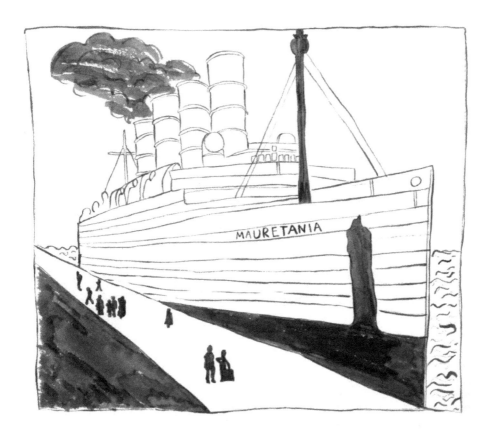

On the 1920 National Census, in Massachusetts, Betsy has disappeared.

Silver Rebecca	Head	R	F	W	46	W
Morris	Son		m	w	26	S
Harry	Son		m	w	24	S
Ada	daughter		F	w	14	s
Leah	daughter		F	W	18	S

Leah met a sailor, got pregnant, and then had Ruth in March of 1921. *I came out of the Bar Harbor Hospital with a nameless girl in my arms.* Ruth's father retreated onto his ship and disappeared. Leah worked when she could, but when she ran out of people willing to watch Ruth for small amounts of money, when she was turned away from charity homes in Boston, she decided to take Ruth to New York and try to place her in a home for children there.

They took a train to the city and stayed at a rooming house on 80th near Lexington Avenue. She gave a fake name.

There are two stories of how Ruth was found in the marsh of Coney Island Creek.

One account says that a young boy found Ruth in the marsh, that he took her home to his mother who thought the dots that covered Ruth might be small pox. His mother called for a doctor to look at her, the doctor determined they were mosquito bites. I confuse this part with the story of the girl in Manhattan who was found murdered in a cellar, the way they had to call a doctor to really determine what they thought they saw in the far corner.

There are some people who can look at bodies, bodies that need diagnosing, all day. I torture myself with an image search to figure out what the rash under my arms could be. My knees weaken, elbows tingle—I have to close the window and hope I will get better.

Some articles say a young boy found Ruth. Some say this boy was an iceman. One just says a milkman noticed her in the marsh.

One printing of the account with boy as iceman says he found her with a goat that *simply stood by the crying baby and watched it sadly.*

Ruth was found on a small marsh island on top of newspaper. They thought she had measles, she gulped milk, was swathed in *medicated cloth.*

He picked up Ruth, he *whistled to the goat and set out for dry land.*

> The Feature Section of
>
> Today's Eagle
>
> Is Inserted in
>
> This Section

Leah, people say they know you, that they've heard your name before, but I don't believe them. Not that you don't warrant knowing, but I've looked everywhere—the only place you exist publicly is in newspaper archives and two census forms, a record of a ship's passage. Leah, if I were to believe my sources I'd say you ceased to exist once you were freed and reunited with your children, but I know that isn't true. Leah most days I can't write about my own life because I am perspective-less, my face is on the freshly turned-off screen and I am licking the static to feel how it feels. Leah I bet they heard a story like yours, a story spoken into a small microphone at a local government meeting discussing the need for child care facilities, a story digested as they flipped past a talk show whose banner tells a name, an age, a notable misstep (Leah – 21 – abandoned baby)—I know they know your story, Leah, but I don't think they know you.

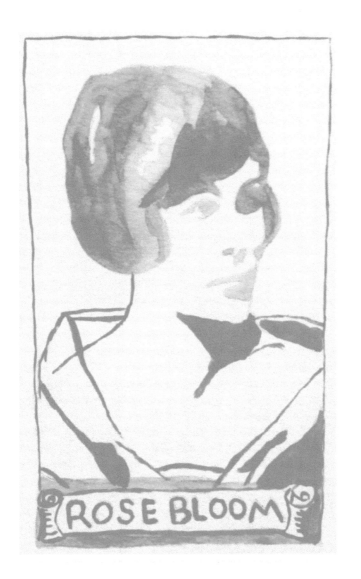

ROSE BLOOM

After she left Ruth, Leah stayed in a New Haven boarding house under the name *Rose Bloom* for less than a week. She chose a name so full of hope, so fully of her feminine powers. Can you imagine giving that name as your own as you check into a boarding house in New Haven, a city where you don't know anyone—after you've just left the child on a beach?

Two women traveled from Lynn to Brooklyn to identify Ruth at the hospital. These two women gave a description of Leah that the police used to facilitate her arrest.

a Jewish girl

Less than five feet in height, not pretty, shabbily dressed and so frail that she appeared to weigh not much more than 100 pounds

showed no signs of worry over her arrest but wept when told of the condition in which her baby was found

Leah Silver, Single

Leah Silver, twenty one, a bit of a girl, with black bobbed hair

Pale and drawn, partially covering her face with her handkerchief

frail, has black bobbed hair, and appeared to be on the verge of a nervous breakdown

the little black-haired girl

A tiny, pitiful creature in her ugly blue hospital wrapper

restlessly sat combing back her bobbed hair

appeared unconcerned when arraigned

smiled wanly as she heard the verdict

When Leah left Ruth in the marsh, she was pregnant with another girl. She named the new baby June Claire.

Leah means *weary.*
Ruth means *friend.*

Rose meant *fame* and *kind,* eventually just *a fragrant flower.*

June is from *Juno,* possibly *youth, protectress of marriage and women.*
Claire is from *Clara: clear, bright, famous.*

June was the last month they three (Ruth, Leah, June) were all together.

The driver told Leah he knew someone who would care for Ruth for $5 a week.

Leah wired to Boston asking a man for money, he sent her $25.

She gave a driver $5 and $1.90 in taxi fare.

Three months after Ruth was born Leah met with the baby's father and asked him
 to marry her but he *refused, saying he was out of work and had no money.*

*...in exchange for $6.90 told of a place where the child would be taken care of for $5
 a week.*

"*... If I would give him fare and $5 extra he would drive me to a place where the
 baby would be found.*"

Leah is held for $5,000 bail.

Leah is released on $2,500 bail—the magistrate reduced it by half when he was
told she was pregnant.

A man who wishes to marry Leah writes to the magistrate and says he owns
 $15,000 worth of property.

Inflation Calculator

If in [1922] (enter year)

I purchased an item for $ [5.00]

then in [2015] (enter year*)

that same **item would cost**: **$70.42**

Cumulative rate of inflation: **1308.3%**

[CALCULATE] [PRINT]

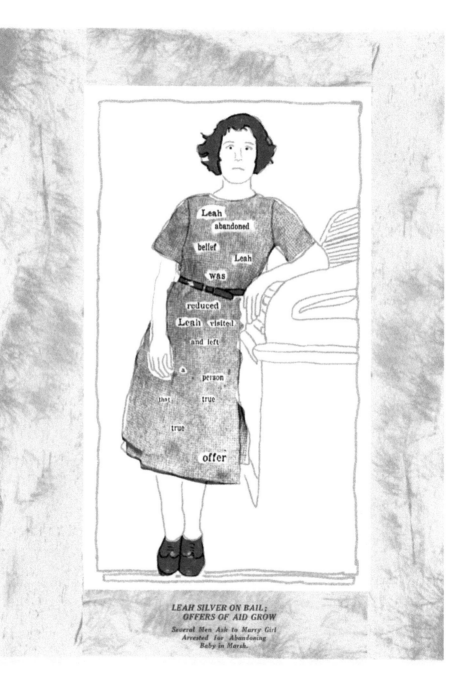

**LEAH SILVER ON BAIL;
OFFERS OF AID GROW**

*Several Men Ask to Marry Girl
Arrested for Abandoning
Baby in Marsh.*

"I think I'll go back and get it," the conductor heard the woman say, striking her hands together nervously.

"No," objected the Italian. *"You did it for the best. Don't go back. Leave it there."*

"I'm not going to have Ruth adopted by anyone, though," she declared however. *"I'm going to bring her up myself."*

She intends to go home to Lynn, Mass. with her mother as soon as she gets out of the hospital, taking her two children with her.

According to her attorney she is seriously considering giving the swamp baby, Ruth, for adoption.

The child has been returned to her.

Leah is something real if no one else is there to witness it? When you were on the train to New Haven after leaving Ruth, was she real to you? Was she with you, or had you become only *you* again?

Willing people and things away usually does not work—I end up visiting their website after midnight, or seeing them in my dreams.

Leah, the world is basically an ongoing series of women becoming and unbecoming mothers. Of course there are some, like me, that are neither—at least neither category fits right now, but I won't know how I fit in until I am dead.

In April of the year you left and un-left Ruth, a former actress adopted the six orphaned children of a man who was murdered on Christmas. *"A month ago I decided that the happiest hour of my life would be that in which this family should become mine and take my name,"* she told the newspaper. *"I believe motherhood is the highest service a woman can give."* She gets two pictures, an offset box, and a italicized headline—fares much better than another mother on the same page only referred to as *wife*, a woman who was her husband's lookout, baby in arms, as he robbed three hundred homes in Chicago over four desperate months. I'm inclined to say that *wife* made more difficult, braver choices, if we can put moral posturing aside for a moment.

Former Actress, Childless, Adopts Six
Children Made Orphans by Murder

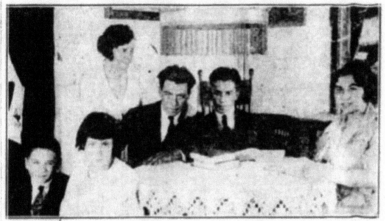

The picture shows, left to right—Edmund, 12; Harriet, 8; Mrs. Harriet C. Collins, their adopted mother; John, 21; Adolph, 15, and Marie Elizabeth, 17. Marion is in Chicago for a few weeks, leaving her little flock.

CONGRESS ACTS TO REMEDY STRIKE EVILS; GIRL ADMITS LEAVING BABY IN SWAMP

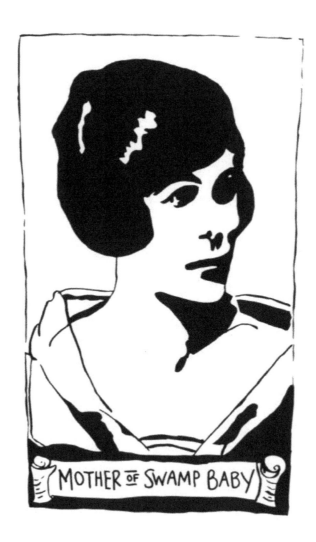

MOTHER OF SWAMP BABY

Ruth is:

July 10	Abandoned Baby
	18-Month-Old Girl
	baby girl
	the child
	the baby
	the little one the child
	the child
July 15	Infant
	her child
	the baby
	the baby
	her baby
	her child
	her child
	the baby
	the little one
	Swamp Baby
July 16	Swamp Baby
	16-month-old girl
	the child
	the little one
	her baby
	her baby, Ruth
	the baby
	my little Ruth
	Ruth
	the baby
	the little one
	the baby
	my little one
	my baby
	her
	the baby
	Ruth
	my child
	the little one
	her

Ruth
her
the baby
her
she
her
her
little Ruth
she
her child
child
Child
16 months old daughter Ruth
the infant
the child *we do things wrong because we care too much*

her baby
little Ruth
little Ruth
the baby
Little Ruth
the baby
her
her
the baby
her
the baby
the baby
little Ruth
little Ruth
the baby
the baby
baby
the baby
the baby
the child

who is resting assured?

July 17 Baby
16-months-old baby girl, Ruth
her child
abandoned baby
this child
the baby
the baby

the baby
Swamp Baby
Child
fifteen-month's-old baby
her child
her first child
the little "swamp baby"
the little one
her child
baby
sixteen-month-old baby
her baby
Daughter
my daughter
her baby
my baby
baby Ruth Silver
Swamp Baby
Baby Ruth
the baby

But it was a friendly world, after all, and she sighed and looked out of the window at the stars

July 18

Baby
a sixteen-month-old daughter
little Ruth Silver
little Ruth Silver
the child
Swamp Baby
the deserted swamp baby
the swamp baby

She suggested either that some person going West take the child there or that the baby be sent parcel post.

July 21

the baby that was found recently deserted in a Coney Island swamp
the swamp baby
her baby

NEW YORK CITY NEWS

July 22

Ruth
14-month-old babe
the child

July 23	the 16-months-old baby girl her baby
July 25	"Swamp" Baby
August 7	"the swamp baby"
September 1	her 16-months-old daughter Ruth
September 11	Swamp Baby her 16-months-old baby The child The little girl the baby the infant
September 12	Baby her daughter Ruth, 16 months old her child
September 13	Baby her 16-months' old baby her daughter the child Baby 16-month-old daughter, Ruth

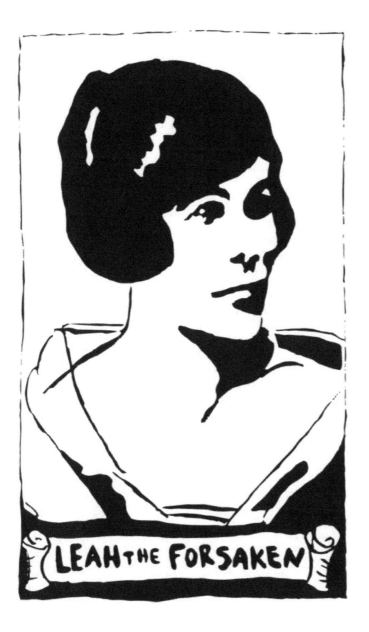

LEAH THE FORSAKEN

Adoption of child (1 results)
Attending school (1 results)
Childbirth (33 results)
Courtship (5 results)
Death of child (53 results)
Death of friend or neighbor (110 results)
Death of other family member (123 results)
Death of parent (49 results)
Death of sibling (35 results)
Death of spouse (26 results)
Divorce or Separation (1 results)
Family reunion (2 results)
Family separation (200 results)
Graduation (12 results)
Household moves (144 results)
Mental illness (1 results)
Physical illness of author (322 results)
Physical illness of child (178 results)
Physical illness of friend or neighbor (122 results)
Physical illness of other family member (161 results)
Physical illness of parent (129 results)
Physical illness of romantic partner (1 results)
Physical illness of sibling (99 results)
Physical illness of spouse (180 results)
Pregnancy (37 results)
Religious experience (2 results)
Spouse's absence (24 results)
Wedding (10 results)
Wounded (2 results)

The website for a famous archive categorizes topics of women's letters and diaries by personal events. I will never read all of the writing categorized. I will never know if the list is a result of the women's situations or the categorizer. They are mostly sad.

Leah I found you in the *Brooklyn Daily Eagle*. Leah I typed your name in and I uncovered each instance your name appeared, I saved them, I printed them out.

Leah I found your image on eBay and I bought it. Leah you came to me from a photograph warehouse in Tennessee, you arrived in Vermont. Leah while you were in transit I traced your photo four times. Leah I think the photo of you I traced was from your graduation.

Leah my favorite part of the tracing and inking are the two sheens in your hair like twin islands so close to being the same thing.

Leah I spent the afternoon looking at Google Maps, trying to approximate the part of the creek where Ruth was found. I was overwhelmed by tire piles, low slung warehouses, the Belt Line which didn't appear until twenty years later. Nothing is ever the same.

Leah I hold my hands in front of your photograph at a distance, trying to imagine you with hair from today, to see if I recognize your face.

Leah what I know about you was all written by men. I would like to change that. Leah all the men wanted to marry you, but I do not trust them, especially the man with coal.

Leah I cannot meet your eyes, your eyes are crossing beams with Ruth's, two faces, too sullen.

Leah I smiled when I realized the hope in your alias. *Rose, bloom. Rose Bloom.*

Leah I pity you but not how they pity you. I pity the world of failed networks around you, I pity the way you had to negotiate the ignorance of men and their systems.

You can now use one of your accesses to view the article that you selected: DEATHS

ABANDONED Children—Ruth Silver found near Coney Island Creek, Jl 10, 3:6; mother sought, Jl 14, 5:2; baby boy abandoned in Bklyn hallway, Jl 19, 17:4; infant found on porch of Dr B Kaufman's home in Bklyn, Jl 24, 17:7; Philomenia and Salvatrice Calandra abandoned in N Y C, Ag 5, 20:3; 3-weeks-old girl found in telephone booth, Ag 27, 16:4; Mrs Rose Fulton arrested on charge of abandoning infant in Ridgewood Day Nursery, S 5, 8:1; infant found on roof with note signed God help the poor, S 14, 23:7; New Yorker will give $250 to writer of " God help the poor " note, S 16, 15:2; baby found in suitcase in cellar; Alice McDermott arrested, S 29, 5:5

See also N Y Soc for the Prevention of Cruelty to Children; Silver, Leah

one of many

I'm not yet sure how one cares for a creature so small and helpless. An apartment building in Chicago in 1922 offered its tenants $25 dollars per baby born while they lived there, $50 for twins. The landlord said that babies make the building a happier place, built a baby carriage storage locker for each apartment on the ground floor. Four days before Ruth spends the night in the creek, a baby in Bay Shore, Long Island is shot and a bullet rests at the base of her brain. In the four o'clock edition of the *Brooklyn Daily Eagle* on July 7, the paper that hits the streets just before you released Ruth from your arms, the Bay Shore baby's family is reported as not knowing what to do. They ask the doctors to wait, not to operate. There are no signs of infection, and moving the bullet would end her. Her mother stares out of the frame at the same absent angle that you do when they hand Ruth back to you in the hospital and snap your photograph so they can run it under the headline *SAD REUNION.*

AFTER-WORDS

Greetings comrade! Thank you for talking to us about your process today!
Can you introduce yourself, in a way that you would choose?

My name is Lesley and I am a writer and artist. I live in Los Angeles with my husband and our two dogs. I'm from Massachusetts and when I dream I'm mostly in New York or lost on a midwestern highway, off ramps after unknown off ramps.

Why are you a poet/writer/artist?

I can't imagine being anything but. It's too late to turn back now.

When did you decide you were a poet/writer/artist (and/or: do you feel comfortable calling yourself a poet/writer/artist, what other titles or affiliations do you prefer/feel are more accurate)?

In fifth grade I went to a Worcester County Young Writers conference, and I have a vivid memory of being in a big room full of other kids and we were all freewriting silently. The feeling in that room stays with me.

What's a "poet" (or "writer" or "artist") anyway?
What do you see as your cultural and social role (in the literary / artistic / creative community and beyond)?

I struggle with this question. Sometimes I wonder whether or not I'm helping the world, or what it matters that I come back to my art forms day after day. But I read something recently that pointed to art as being something that humans can see our interconnectedness in, something to let us know we are not alone, that we share experiences and emotions and are tethered together in all sorts of invisible ways. I like that.

Talk about the process or instinct to move these poems (or your work in general) as independent entities into a body of work. How and why did this happen? Have you had this intention for a while? What encouraged and/or confounded this (or a book, in general) coming together? Was it a struggle?

The Leah sections of the book came first. I started them when I moved from Brooklyn to Iowa City and was having a difficult time adjusting to the Midwest. I took a research poetics class with Cole Swensen, and my longing for New York drove

me to scour archives for a story I could latch onto. When I found Leah, and the other babies abandoned on Coney Island, it felt right. I needed to uncover as much as I could about her. She was from Massachusetts (as am I) and ended up having this totally life-changing, terrifying thing happen in Brooklyn.

I worked on those sections on and off for five or six years. Working in the text and visual modes was exciting for me—I realized that I did not have to groom my natural inclinations to fit the forms of poetry that I had read and been taught. It felt like a true representation of myself as a writer. While working on the Leah project while at a residency in Vermont I really thought I was going to write a non-fiction book, or a historical novel, and would have to circle back around to the fact that not only do I not know how to do those things, I preferred working in this hybrid mode even though it felt free-form or uncharted.

The other parts of the book all came separate. "In Service of Him or, What I Thought Service Was," also took a few years to come together. Writing about abuse, about my abuse, was something I thought would never happen. But as I saw many women coming forward and sharing their experiences—especially within the writing community—I realized how important it was to commit my story to paper. The catharsis of writing it was spurred on by the strength and understanding I felt by simply reading the stories of others.

All the while I'd been writing and putting aside poem-poems, and the ones that appear in this book are together a velvet door stopper tempering the more unruly aspects of experience. There's many other poem-like poems that didn't work for this book. I made a handful of manuscripts of these other poems, sent them out all over the place and nothing seemed to connect. It took a lot of deep consideration to realize that I had the pieces to the manuscript that I had been wanting to make all along right in front of me—I was truly unsure of how it would be perceived, what with all of its incongruous forms and modes. But when I put the essays, the poems, all of the pieces together, I knew that it made a whole.

What formal structures or other constrictive practices (if any) do you use in the creation of your work? Have certain teachers or instructive environments, or readings/writings/ work of other creative people informed the way you work/write?

Not many! In fact, it was key to this manuscript to avoid a prescribed format. In some way, the constriction was to be true to my writing and not go back and undercut or edit out my instincts in favor of something more "recognizable." It's the most challenging to be honest with myself. I'm lucky to have studied under many writers I adore (Sarah Manguso, Megan Kaminski, D.A. Powell, Cole Swensen, Jen Bervin, Brian Blanchfield, to name a few) in a range of environments. The continual internal conversation I am allowed to sustain with myself and writing through all of these learning environments has helped me to define and redefine my work. And my writing would not exist without my visual art practice—oscillating between the two mediums is what keeps me engaged with expression.

Speaking of monikers, what does your title represent? How was it generated? Talk about the way you titled the book, and how your process of naming (individual pieces, sections, etc) influences you and/or colors your work specifically.

Abandoners first was the title of the last piece in the book. The word appeared in nearly every news article I found about Leah. I decided to make it not only the title of this piece but of the whole manuscript because of the way it seemed to shimmer when held up to the themes that run throughout. Abandoning as a way of shedding what is not needed, abandoning as hopelessness, as a choice, or as something that happens to you. A celebration of abandonment.

What does this particular work represent to you as indicative of your method/creative practice? your history? your mission/intentions/hopes/plans?

This work has the past ten years of my life wrapped up in it. It's made of all the modes I work in. This whole process has affirmed my belief in negative capability, as difficult as it may be to trust in it.

What does this book DO (as much as what it says or contains)?
What would be the best possible outcome for this book? What might it do in the world, and how will its presence as an object facilitate your creative role in your community and beyond? What are your hopes for this book, and for your practice?

I hope someone reads *Abandoners* and leaves with new ideas or is happy to have spent time with the book. I see *Abandoners* as a questioning of linear time, animating the archived alongside the now. Who else is in the archives, or more importantly, left out of the archives? How can we ensure their stories are heard? I hope this book does some work of unerasing the overwritten.

Let's talk a little bit about the role of poetics and creative community in social activism, in particular in what I call "Civil Rights 2.0," which has remained immediately present all around us in the time leading up to this series' publication. I'd be curious to hear some thoughts on the challenges we face in speaking and publishing across lines of race, age, privilege, social/cultural background, and sexuality within the community, vs. the dangers of remaining and producing in isolated "silos."

Finding the archival material for this book was magical for me. To sift through newspapers and censuses available freely online and in libraries and find these stories is a reminder to me of the importance of preserving information for those who come after us. I was able to collaborate with writers and people from the past, to build on what they started. In that way it was a self-perpetuating endeavor—because I found stories that inspired me, I was able to tell my own story in hopes that someone else would find it when they needed it. It is not easy to be honest in writing, but it is important—we see ourselves more clearly when we see each other truthfully.

ACKNOWLEDGMENTS

Gratitude to the editors of the journals where these pieces, or early versions of them, first appeared:

"A Little Hell of Its Own" was selected by Barbara Henning to win *Bone Bouquet*'s 2014 Experimental Prose Contest, and appeared in issue 5.1.

"In Service of Him or, What I Thought Service Was," first appeared in *Entropy Magazine*.

"Next Lifetime" appears in the liner notes of *Live at Steinway Hall* by Self-Imposed Exile.

"Abandoners" appeared in *Omniverse*.

Many people and places helped me shape the work in this book. Thank you Mom and Dad, Ben and Kate, Hugo and Dinah—and to Megan Kaminski, Rhiannon Dickerson, Alyse Bensel, Sally McVey, Russell Jaffe, Katelyn Keating, Chad Cliburn, Rachael Small, Deb and Chuck, dee mcelhattan, Danny Caine, Heidi Adams, Aaron Kruziki, Maeve Royce, Jake L'Ecuyer, my classmates at Iowa and Kansas, the students and grown-ups of P370K@P100, empty Coney Island benches on lunch breaks, empty Missouri highways, and empty Kansas afternoons. A deep gratitude to Elæ [Lynne DeSilva-Johnson]; thank you for believing in my work.

Much of this book was written at the Vermont Studio Center. My immense gratitude to VSC and the people I was lucky enough to be there with.

And my love and thanks to Karl, painter of mountains, conjurer of quarter notes, sweet boo of my heart. How lucky to wake up in the sunshine with you.

L. Ann Wheeler is a writer, artist, and teacher in Los Angeles. She holds degrees in creative writing from the Pratt Institute and the Iowa Writers' Workshop. Her poetry and prose has appeared in *Omniverse, Bone Bouquet, Entropy, ILK,* among others. She's taught elementary school on Coney Island, college writing in Iowa, Missouri, and Kansas, and high school in California. *Abandoners* is her first book. [photo: Mercedes Lucero]

*The Operating System uses the language "print document" to differentiate from the book-object as part of our mission to distinguish the act of documentation-in-book-FORM from the act of publishing as a backwards-facing replication of the book's agentive *role* as it may have appeared the last several centuries of its history. Ultimately, I approach the book as TECHNOLOGY: one of a variety of printed documents (in this case,* bound*) that humans have invented and in turn used to archive and disseminate ideas, beliefs, stories, and other evidence of production.*

Ownership and use of printing presses and access to (or restriction of printed materials) has long been a site of struggle, related in many ways to revolutionary activity and the fight for civil rights and free speech all over the world. While (in many countries) the contemporary quotidian landscape has indeed drastically shifted in its access to platforms for sharing information and in the widespread ability to "publish" digitally, even with extremely limited resources, the importance of publication on physical media has not diminished. In fact, this may be the most critical time in recent history for activist groups, artists, and others to insist upon learning, establishing, and encouraging personal and community documentation practices. Hear me out.

With The OS's print endeavors I wanted to open up a conversation about this: the ultimately radical, transgressive act of creating PRINT /DOCUMENTATION in the digital age. It's a question of the archive, and of history: who gets to tell the story, and what evidence of our life, our behaviors, our experiences are we leaving behind? We can know little to nothing about the future into which we're leaving an unprecedentedly digital document trail — but we can be assured that publications, government agencies, museums, schools, and other institutional powers that be will continue to leave BOTH a digital and print version of their production for the official record. Will we?

As a (rogue) anthropologist and long time academic, I can easily pull up many accounts about how lives, behaviors, experiences — how THE STORY of a time or place — was pieced together using the deep study of correspondence, notebooks, and other physical documents which are no longer the norm in many lives and practices. As we move our creative behaviors towards digital note taking, and even audio and video, what can we predict about future technology that is in any way assuring that our stories will be accurately told – or told at all? How will we leave these things for the record?

In these documents we say:
WE WERE HERE, WE EXISTED, WE HAVE A DIFFERENT STORY

- Elæ [Lynne DeSilva-Johnson], Founder/Creative Director
THE OPERATING SYSTEM, Brooklyn NY 2018

RECENT & FORTHCOMING
OS PRINT::DOCUMENTS and PROJECTS, 2018-19

2019

Ark Hive-Marthe Reed
I Made for You a New Machine and All it Does is Hope - Richard Lucyshyn
Illusory Borders-Heidi Reszies
A Year of Misreading the Wildcats - Orchid Tierney
We Are Never The Victims - Timothy DuWhite
Of Color: Poets' Ways of Making | An Anthology of Essays on Transformative Poetics -
Amanda Galvan Huynh & Luisa A. Igloria, Editors

KIN(D)* Texts and Projects

A Bony Framework for the Tangible Universe-D. Allen
Opera on TV-James Brunton
Hall of Waters-Berry Grass
Transitional Object-Adrian Silbernagel

Glossarium: Unsilenced Texts and Translations

Śnienie / Dreaming - Marta Zelwan/Krystyna Sakowicz, (Poland, trans. Victoria Miluch)
Alparegho: Pareil-À-Rien / Alparegho, Like Nothing Else - Hélène Sanguinetti
(France, trans. Ann Cefola)
High Tide Of The Eyes - Bijan Elahi (Farsi-English/dual-language)
trans. Rebecca Ruth Gould and Kayvan Tahmasebian
 In the Drying Shed of Souls: Poetry from Cuba's Generation Zero
Katherine Hedeen and Víctor Rodríguez Núñez, translators/editors
Street Gloss - Brent Armendinger with translations for Alejandro Méndez, Mercedes
Roffé, Fabián Casas, Diana Bellessi, and Néstor Perlongher (Argentina)
Operation on a Malignant Body - Sergio Loo (Mexico, trans. Will Stockton)
Are There Copper Pipes in Heaven - Katrin Ottarsdóttir
(Faroe Islands, trans. Matthew Landrum)

2019 CHAPBOOKS

Print::Document Chapbook Series (7th Annual)

Vela. - Knar Gavin
[零] A Phantom Zero - Ryu Ando
RE: Verses - Kristina Darling and Chris Campanioni
Don't Be Scared - Magdalena Zurawski

Digital Chapbook Series (2018-19)

The American Policy Player's Guide and Dream Book - Rachel Zolf
Flight of the Mothman - Gyasi Hall
Mass Transitions - Sue Landers
The George Oppen Memorial BBQ - Eric Benick

An Absence So Great and Spontaneous It Is Evidence of Light - Anne Gorrick
The Book of Everyday Instruction - Chloë Bass
Executive Orders Vol. II - a collaboration with the Organism for Poetic Research
One More Revolution - Andrea Mazzariello
The Suitcase Tree - Filip Marinovich
Chlorosis - Michael Flatt and Derrick Mund
Sussuros a Mi Padre - Erick Sáenz
Sharing Plastic - Blake Nemec
In Corpore Sano : Creative Practice and the Challenged Body [Anthology]
Abandoners - L. Ann Wheeler
Jazzercise is a Language - Gabriel Ojeda-Sague
Born Again - Ivy Johnson
Attendance - Rocío Carlos and Rachel McLeod Kaminer
Singing for Nothing - Wally Swist
The Ways of the Monster - Jay Besemer
Walking Away From Explosions in Slow Motion - Gregory Crosby
Field Guide to Autobiography - Melissa Eleftherion

Glossarium: Unsilenced Texts and Translations

The Book of Sounds - Mehdi Navid (Farsi dual language, trans. Tina Rahimi
Kawsay: The Flame of the Jungle - María Vázquez Valdez (Mexico, trans. Margaret Randall)
Return Trip / Viaje Al Regreso - Israel Dominguez; (Cuba, trans. Margaret Randall)

2018 CHAPBOOK SERIES (6TH ANNUAL)

Want-catcher - Adra Raine
We, The Monstrous - Mark DuCharme;
Greater Grave - Jacq Greyja
Needles of Itching Feathers - Jared Schickling

for our full catalog please visit:
https://squareup.com/store/the-operating-system/

deeply discounted Book of the Month and Chapbook Series subscriptions
are a great way to support the OS's projects and publications!
sign up at: http://www.theoperatingsystem.org/subscribe-join/

DOC U MENT
/däkyəmənt/

First meant "instruction" or "evidence," whether written or not.

noun - a piece of written, printed, or electronic matter that provides information or evidence or that serves as an official record
verb - record (something) in written, photographic, or other form
synonyms - paper - deed - record - writing - act - instrument

[*Middle English, precept, from Old French, from Latin documentum, example, proof, from docre, to teach; see dek- in Indo-European roots.*]

Who is responsible for the manufacture of value?

Based on what supercilious ontology have we landed in a space
where we vie against other creative people in vain pursuit
of the fleeting credibilities of the scarcity economy, rather than
freely collaborating and sharing openly with each other
in ecstatic celebration of MAKING?

While we understand and acknowledge the economic pressures and fear-mongering that
threatens to dominate and crush the creative impulse, we also believe that
now more than ever we have the tools to relinquish agency via cooperative means,
fueled by the fires of the Open Source Movement.

**Looking out across the invisible vistas of that rhizomatic parallel country
we can begin to see our community beyond constraints,
in the place where intention meets
resilient, proactive, collaborative organization.**

Here is a document born of that belief, sown purely of imagination and will.
When we document we assert. We print to make real, to reify our being there.
When we do so with mindful intention to address our process,
to open our work to others, to create beauty in words in space,
to respect and acknowledge the strength of the page
we now hold physical, a thing in our hand,
we remind ourselves that, like Dorothy:
we had the power all along, my dears.

THE PRINT! DOCUMENT SERIES
is a project of
the trouble with bartleby
in collaboration with
the operating system